DECEMBER

THE
SEAGULL
LIBRARY OF
GERMAN
LITERATURE

ALEXANDER KLUGE

39 stories

DECEMBER

GERHARD RICHTER

39 pictures

TRANSLATED BY MARTIN CHALMERS

LONDON NEW YORK CALCUTTA

 GOETHE INSTITUT

This publication was supported by a grant
from the Goethe-Institut India

Seagull Books, 2021

Alexander Kluge/Gerhard Richter, *Dezember. 39 Geschichten. 39 Bilder.*
© Suhrkamp Verlag, Berlin, 2010

The texts '3 December 1931' and 'The Old Dragon beneath the
Temple Mount' appeared in a slightly different form in Alexander
Kluge, *The Devil's Blind Spot: Tales From the New Century* (Martin
Chalmers and Michael Hulse trans) (New York: New Directions,
2004).

First published in English translation by Seagull Books, 2012
Translation © Esther Kinsky, 2014

Additional work by Thomas Combrink

ISBN 978 0 8574 2 820 2

British Library Cataloguing-in-Publication Data
A catalogue record for this book is available
from the British Library

Typeset and designed by Sunandini Banerjee, Seagull Books
Printed and bound by WordsWorth India, New Delhi, India

DECEMBER

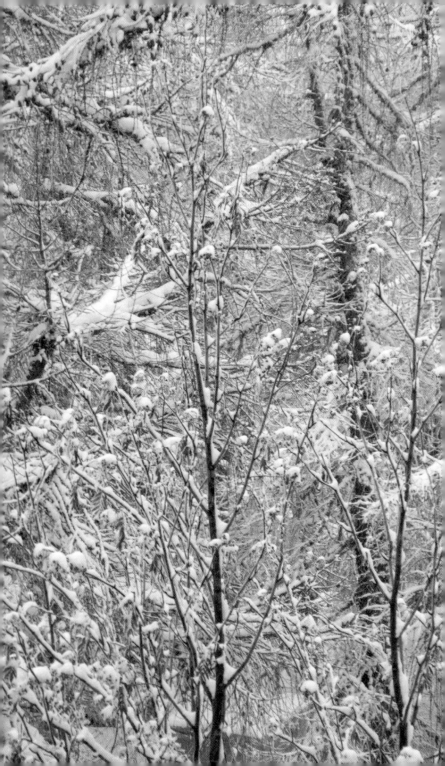

1 December 1941: Ice storm on the front line outside Moscow.

There ought to be two armies in reserve, says General Field Marshal Fedor von Bock, speaking to Army High Command by telephone at about 5 p.m. Really, he continues, we don't need any weapons to fight the Russians but a weapon to fight the weather. In the homes of Germany there is no immediate awareness of these events in the East.

Dr Fred Sauer, formerly of Siemens, working in the Research Section of the Army Weaponry Office, is investigating the anatomy of mammoths. Could a winterproof tank weapon be developed drawing on the short rumps and thick-set bodies of these experienced giants of the frozen steppes (which, with their dusty, unceasing, extremely cold east winds, no longer exist in 1941)? In the massive pillar legs, according to Sauer, the oxygenous blood flowing from the body of these beasts warmed the spent cold blood rising up into the body. This feature pointed towards the possibility of developing a makeshift defence against the wiles of the Russian winter by providing engines with a double circulation (one to heat the engine itself and one for the drive). The project comes too late to be decisive that year.

The month of December 1941 was characterized by time shortage.

2 December 1991: In the slushy winter of 1991 Mikhail Gorbachev was still resident in the chambers of the Kremlin. Lenin's room with its easy chairs draped in linen sheets was still there, two buildings away from Gorbachev. The telephone exchange to the left, with antiquated apparatus from the 1920s, was also preserved.

Power was not lying in the street, it was hidden and built into the walls of the Kremlin in the shape of utility pipes and personal networks. A staff of perhaps sixteen faithful followers who have never learnt anything practical (apart from preparing meetings and conferences) is not enough to find these power lines concealed in the walls, pipes and cables. The plaster would have to be knocked off: POWER LIES HIDDEN IN THE PLASTERWORK. A demolition, thought Gorbachev, was the real task and three years ago, with a 'PARTY OF THE SOCIAL BUILDING WORKER', it would still have been possible to execute (as complete reconstruction of the whole country). He was tired. Now of all times, at a twilight hour of the December in which he and everyone else was waiting for the end of the crisis, he wanted to have a DEBATE. Through the window he saw solid walls, fir trees and slush, snow trodden by many feet.

— Where was he sitting?

— In his room. Ordered a tray with coffee.

— What next? Made notes?

— Began to make notes for his memoirs. Then we knew: it's all over.

3 December 1931: Sleet coming down on the roads of Mecklenburg. Hitler (in his black Mercedes) and the mother of the bride of Josef Goebbels (in a red Maybach) were very nearly killed by the substitute chauffeur of the estate where the wedding had taken place. In those early days of motoring, wariness about braking on icy surfaces and driving while under the influence were not much on everyone's mind. The drivers on the return journey had, just like the ladies and gentlemen, been indulging heartily in alcoholic drinks.

It was the general view, however, that the operations of heart and mind at the steering wheel are not inhibited by the intake of spirits, but inspired. Nothing works so quickly as in a state of intoxication, not unlike the engines which are themselves forces of nature. They have horse hooves, wings and breathe gas. They aren't wild but mechanical servants of the expert hand of the person who, with foot and gentle manipulation of gear stick and steering wheel, keeps these powers in fluid motion. Admittedly a tipsy driver has difficulty controlling his tongue and the volume of his voice but against that is all the more in charge of cannon and cars.[1]

1 After a lively party in Hanover, a lady respected in the society of the town of H. loaded her drunken husband into the back of the Rolls Royce and in a champagne mood drove the car from Hanover to H., encountering no oncoming traffic. With the help of the maid she heaved her husband into bed. They slept until the afternoon. I was already inside the lady. On the other hand, after she had seen the accident, this same lady stopped her car for an hour and a half. She was very bored. Nevertheless the *duplication of events* had to be taken into account. Because one accident attracts another.

On a long gentle curve the driver of the Maybach tried to overtake Hitler's car. When he noticed the vehicle beginning to skid he stepped on the brakes.

—It's only thanks to Providence that the vehicles missed one another.

—What do you mean by Providence?

The engineer said that to the District Administrator. They'd been coming from the same wedding, knew the estate manager and were not disposed to call the police. The irresponsibility of the substitute chauffeur could be easily established without them.

The District Administrator offered all those involved in the accident schnapps from a flat silver flask. Meanwhile a replacement car for the mother of the bride had arrived: one of Hitler's adjutants had gone to the nearest telephone at a trot (fifty yards running, one hundred yards walking). You may continue, Mr Hitler, said the District Administrator. The curious accident was an interesting topic of conversation for him for a fortnight.[2]

2 I, enclosed in the well-tempered stomach, was almost born without Hitler having a bit of future in front of him. Only another 15–16 inches and the two powerful vehicles would have collided on the icy surface with fatal consequences.

4 December 1941: There was a huge area of high pressure over the Atlantic with its centre to the south-west of Ireland. A weak ridge extended in a north-easterly direction over Scandinavia as far as the Arctic Ocean. It separated an extensive low-pressure area over the Polar Sea from a weaker low-pressure area over Russia. At its base cold continental Arctic air mingled with cloud masses pushing up from the south. This was the causal chain which brought about the sudden cold spell of December 1941. According to weather researcher and meteorologist Dr Hofmeister of the Potsdam Weather Station, by applying the principle of DYNAMIC METEOROLOGY the German forces could have been warned ten days beforehand. In the past, augurs predicted the outcome of a battle by examining the entrails of their sacrificial animals before the fighting began. Today, in the rational December of 1941, meteorologists have replaced the augurs.

DYNAMIC METEOROLOGY does not investigate the actual state of the weather but concentrates its observations on the large-scale movements of the overall circulation which precede and create the distinct shifts in weather. As is proper for a National Socialist, this 'totality' is to be ascertained with the tools of INTUITION and not with the methods of PROVABILITY.

The school of dynamic meteorology pressed for 'an active intervention in weather conditions'. In order for that to happen, air squadrons would, if necessary, have to bomb cloud masses to a breadth and length of several hundred miles with

dry ice and carbonic acid packs. That would only make sense if one knew in advance what such an active intervention set in motion. Dynamic meteorology came too late for the battles on the Eastern Front. On 4 December, however, even before the government departments of the Reich shut down for the St Nicholas holiday, which had been brought forward, Dr Hofmeister's workgroup received confirmation of a government credit to the value of 500,000 Reichsmarks for their research. This could be called the 'beginning of the era of dynamic meteorology'.

5 December 1942: In order to explain the principle, said Heiner Müller, why Stalingrad was on the one hand historically necessary and on the other, from the perspective of human beings, not at all, I have to tell a fictitious story.

Captain Slopotka, Viennese by birth, was transferred to Stalingrad as late as December 1942, thanks to the incompetence of the army administration. Those who in October had initialled the transfer memo knew nothing of the encirclement. He landed at Pitomnik airfield in the middle of a snowstorm. Only days before he had been bathing in the mild winter waters of the Mediterranean at Catania.

He had missed out on all the learning processes in the Stalingrad pocket, had not been subject to the physical emaciation which had already begun in September. He now arrived in the pocket with a fresh view of things. A parachute division, had it been dropped on the winter surface, equipped with special winter clothing and large quantities of ammunition, would have been in the same good spirits and have guaranteed the defence of Stalingrad until early March.

Slopotka, said Müller, becoming more animated, was shocked by the virtually doctrinaire belief of his comrades in the encircled area in their own misfortune. As transport officer, he immediately took charge of snow-clearing duties on the relief airstrip at Stalingradski. Following the suggestion of Air Force Field Marshal Milch, five to seven new airfields were to be organized from scratch in the pocket and that within three days. Slopotka's vigour, which derived solely from the fact that

he had arrived there from another current of reality, was transmitted to his small team. He swept them along. He planned to graduate as an engineer the following year and to take a training course to fly transport planes.

Slopotka's clear spirit did not dominate anything more than the narrow radius of the small airstrip which was still in the same condition in which the Russians had abandoned it in the autumn. It was even impossible to rouse from their lethargy the wireless operators at Pitomnik who maintained radiotelephone communication with the forward air base from which aircraft started for the pocket. So no transport planes were directed to the now cleared runway.

On 24 January, the small group organized by Slopotka was overrun. The Red Army was not interested in the mental state of those it left lying to right and left. Slopotka's corpse was in a group of dead, leant up against a layered heap of snow, distinguishable from the other dead only in that the layer of fat under his skin still appeared intact.

Key word: BASILISK GAZE. The merchants in the Netherlands, says Müller, were not well versed in the exercise of power and stood back when Alba had Count Egmont executed. They didn't read the signs. The GDR (East Germany) capitulated in just the same way. Yesterday Valentin Falin visited me, Müller continued. Falin was not at Stalingrad himself. But he had probably read every line in the Kremlin's secret files about it. According to them, the Russian commanders assumed they had surrounded 86,000 men in their surprise

11

attack. In fact it was 300,000. In terms of numbers, there were never more troops in the encircling front than there were Germans in the pocket. What causes an army committed to lightning war to declare itself defenceless within a matter of two months? The battle is decided, says Müller, in the heads of the fighters.

> Recently at my house a cat was seen watching a bird on a treetop and, after they had locked gazes for some time, the bird let itself fall as if dead between the cat's paws, either intoxicated by its own imagination or drawn by some attracting power of the cat. —Montaigne, 'Of the Power of the Imagination' (*Michel de Montaigne*: *The Complete Works*, Donald Frame trans., London, 2003).

6 December 1989: Jerusalem. During excavation work under the Dome of the Rock, engineers had uncovered a gallery which led three hundred yards deep down into the hill. Greedy for finds from antiquity and in accordance with their instructions which concerned the investigation of the stability of the substratum, they set foot in the tunnel, possibly a relic of earlier phases of the building of Jerusalem. As they moved forward in the subterranean passage with their equipment, the floor gave way and they found themselves trapped in a pit thirty-six feet high with no opening in the surrounding walls. Their mobile phones were still intact and they were able to organize help from above.

The depths of the Temple Mount, reported the men who had been rescued, were crumbling throughout. Further construction and excavation were inadvisable. What would one expect to find at a depth of five hundred yards, what at two and half miles, what at forty miles? Tunnelling under the Temple Mount without the permission of the Palestinian Building Authority had already been forbidden as long ago as the time of the statute of the British occupying power. The engineers had been digging here illegally. If they had lost their lives when the gallery floor collapsed, the company which employed them would have had to invent some cock-and-bull story. After recovery, their corpses would have been ferried to a place where the accident would have been reconstructed.

The OLD DRAGON beneath the Temple Mount

There's a green glint to the icy landscape. There's a lake. At its edges: piled up ice and no path. Here the crater stretches out into a landscape without horizons. It is the ninth and deepest circle of hell. In the middle of the lake — in which the worst evil-doers of history are frozen — rests the MIGHTY DRAGON, held fast in the ice up to his diaphragm (if the enormous man-like monster possesses such a thing). Unable to fly off, evidently insensitive to the cold, he has been waiting like this for aeons.[3]

— What lies beneath the Temple Mount?

— A crater.

— Broader at its base than Jerusalem?

— It always has been.

— But coming to such a fine point at the earth's surface that not even a microscope would find the entrance?

— 'Pinpoint small' would be one way of putting it. Nanoscopically small. And then covered by a layer of rubble.

— How do we know these details?

— They have been handed down reliably by Virgil and Dante.[4]

3 The SECOND-MOST ALL-POWERFUL could certainly break chains. Cold is GOD'S CHAIN.

4 One should not allow oneself to be confused by the references to places in Dante (*The Divine Comedy*: *Inferno* 24). According to it, the crater would 'come to a point at the centre of the earth'. Drilling at the Temple Mount has not confirmed this. References to place in eso-teric reports frequently have to be read as mirror inversions.

—Why do you call the creature fixed in the ice the OLD DRAGON?

—That's what he's called. He has wings. They're half stuck in the ice. His head tilts forward.

—Can the Evil One 'tilt' it at all, as immobile as he is?

—The movement is fixed for thousands of years.

—Exactly a thousand years *before* the Last Judgement the lake melts? And the monster bursts through to the surface of the earth and seizes power? Until God yet again vanquishes this second most All-Powerful and puts him on trial before his court?

—Seems like the way the creature holds on beneath the Temple Mount, he's like a ticking bomb.

—That's true of the Temple Mount altogether.

—What happens if the crater is penetrated by drilling? Does the whole thing explode? Does it fall in on itself?

—It's an anti-world.

—It says here in *The Divine Comedy* that the continued existence of our world depends on the continued existence of the anti-world.

—Yes, a question of equilibrium.

—And to whose advantage would it be if the equilibrium were lost?

—No one can know that in advance.

—And why isn't hell hot?

—At its deepest point it's cold.

7 December 1932: Tomorrow the film *Adventure in the Engadine* has its premiere in Berlin. Director: Max Obal. In the leading roles: Guzzi Lantschner and Walter Riml. Music by Paul Dessau. The film involves sport and chase scenes against a backdrop of snow-covered landscapes. Press interviews over afternoon tea at the Adlon Hotel. Trolleys with towers of layered sandwiches are wheeled into the excited discussion. A film whose press interviews take place in the surroundings of such a well-heated hotel is already a success for that reason alone.

Storehouse of Happiness is dropped

To see out the year 1932 Max Reinhardt planned a New Year's Eve revue with the working title *Storehouse of Happiness*! With Zarah Leander as lead, music by Friedrich Holländer, overall conception: Ödön von Horváth. The rehearsals in the Grosses Schauspielhaus in Berlin were broken off. Horváth had asked for all the sets, now stored in barns in Mecklenburg, which had accumulated since 1920. The revue was intended to present a GREAT THEATRE OF THE WORLD, a leave taking.

The show was divided into nine parts: America, Kitchen, Naples, South Seas, Orient, Vienna, Rhine, North Pole and Paradise. Vienna, in Horváth's plan, would be a place always closed for repairs. Open would be a small pre-war section from 1912. The nine parts would be set up on a revolving stage.

It all proved to be far too expensive.

Instead of Horváth's revue Mischa Spoliansky's piece *100 Yards of Happiness* is rehearsed. Were Reinhardt and Horváth faint-hearted or niggardly as far as the cancellation of the project *Storehouse of Happiness* is concerned? They were superstitious.

8 December 1941: Blue Monday. The machinery of the Reich government slowly gets going after the holiday. The Führer, who rises from bed at eleven in the morning, is active until one at night.

The invitation of SS General Heydrich to a conference of all relevant departments, organized by Reich Security Head Office, was for 8 December 1941. The meeting was postponed for six weeks to 20 January 1942. This was the WANNSEE CONFERENCE. It was anticipated that the Reichstag would be convened on 8 December 1941. In 2006 the Darwinist (biologist and historian) Horst Boecker investigated the phenomenon of short-term evolutions using the example of December 1941. His question is this: How does the ONE CERTAINTY which leads to catastrophe develop from a muddled structure of uncertainties, while other uncertainties ('possibilities') simply dissipate? Boecker is working on a 'Biological History of Evil'.

—Would a 'Wannsee Conference' on 8 December have taken a different course from the historical one on 20 January 1942?

—Probably.

—Why?

—Because of time pressure.

IN THIS MONTH OF DECEMBER CHARACTERIZED
BY SPEEDED-UP TIME THERE WAS NO ROOM
EVEN FOR THE CAREFUL ORGANIZATION OF
CRIME.

Evil at the Experimental Stage

'Freedom to do good is greater freedom
than freedom to do bad.'

Thomas Aquinas, *Il Sententiarum*

They were close friends, had known each other for twenty
years. On that day at the beginning of December they were
sitting in Sauerland villa that belonged to one of them, an
Advent wreath on the table. Prepared by the master of the
house himself: tea with rum. In the Reich they were consid-
ered famous conservatives. Regarded with suspicion in the
National Socialist movement by the young and those on the
left.

For both, freedom had nothing to do with the exercise of
the right to vote. Freedom, rather, was a physical state in
human brains and bodies (consequently also in the body
politic): the unpredictable OSCILLATION in a human being
that corresponded to God's breath and over aeons maintained
a 'nervousness' in humans which meant strength. This quality
was just as important for the constitution of COURAGE as
for the POWERS OF DISCERNMENT, as for DEVO-

TION TO A CAUSE, as for SELF-CONFIDENCE. To that extent the two conservative legal scholars were here in agreement with Thomas Aquinas: freedom was a LIVING STATE, no means towards anything, and consequently the good, as that which was easier for freedom, was a further necessary physical state in which human beings, nations and the NOMOS OF EARTH could be kept in motion. If freedom were ever to evolve in such a way that it would better flourish in the REALM OF EVIL, then this would be a turning point and not solely on moral grounds. The two conservatives would have been prepared to sacrifice the moral aspect. They did not want to be confronted, however, with a freedom (which they already exercised inwardly in any case) they would not have recognized. In this respect they were uneasy.

—And if the majority of people (e.g. in a nation that is preparing to leave its island) becomes accustomed to evil. If it binds the freedom which—if I understand you and Thomas Aquinas rightly—is indispensable to the bad, therefore, would that be directed towards something impossible? What happens if the majority of people habitually does evil?

—Then you would have to tell me 'which evil'. There are, after all, many and blatant examples of such a kind. But up to this Advent of 1941 there are no majorities of it. So far THE EVOLUTIONARY OPPORTUNITY OF EVIL has not been great.

—You mean, those who chose evil have usually not survived? They had few children? They started out with ambitions and matters soon faltered?

—Evil's progress remains at the experimental stage.[5]

5 Biochemist Martin Eigen of Göttingen, who possessed a copy of this conversation between the two conservative scholars which had been taken down by a stenographer, has calculated on his computer the capacity for survival of Good and Bad under conditions of freedom. He comes to the conclusion that with an increasing degree of human or divine capacity for decision-making, then for lack of averageness, evil falls statistically behind (because arrogant, because extremely taxing, because unsociable). The condition is that the good is first of all defined, e.g. 'it does one good', 'good behaviour', an object is of the 'familiar good quality', 'goods for export'. Consequently, Eigen classifies 'phantasms of the good' as belonging with the 'bad'. The transition of freedom to the good depends, he says, with reference to another passage in Thomas Aquinas, on the correct definition of the good (it's a question of the 'use value of the good').

9 December 1941: Because the classes of the Cathedral Grammar School and of the Martineum, both of which had to vacate their buildings, have to share the same temporary premises, lessons take place in the afternoon.

After that we fan out to collect scrap metal. There is *one* point for a kilo of iron, *seven* points for zinc, *three* for copper and *six* for tin. For forty points we receive a commendation. We rarely find tin. Zinc, that's toothpaste tubes. Copper we find in scrapped electrical appliances. Guided by our teachers, we collect raw materials for the armaments of the Reich.

Dimmed electric light behind the windows of the houses. The strict blackout does not begin until 7 p.m. The light sources correspond to the energy in our ambitious hearts. How invigorating the cold air we draw into our lungs! Now we are not yet soldiers. Now we are not yet dead. On hand-carts we pull a heavy load which we have brought together from the cellars and attics of the houses. We are taking a hundredweight engine block through the snow. We have removed posts and iron spikes of an ornamental railing.

10 December 1932: In Athens the stock exchange, closed in November 1931 after the crisis caused by the collapse of banks, resumes trading.

'Seeking with the soul the land of the Greeks.' This sentiment led to the liberation struggle of the Hellenes which, with German and British help (Hölderlin writes 'Hyperion', Lord Byron dies of a cold during the fighting), is brought to a victorious conclusion. Bavarian officials, who accompanied King Otto, established the first financial structures in the country now freed from Ottoman rule. These civil servants and the son of the Bavarian king were later ungratefully chased out of the country.

10 December 1941: The value of the drachma goes through the floor. The financial magicians of the Third Reich, plenipotentiaries armed with special powers, were in action. In those days the Reichsbank no longer possessed 'honest money'. What was stored in the vaults was 'looted gold'. Tons of it were brought to Athens. The Reich had occupied Greece, now the Reich was responsible for prosperity and growth.

On the Führer's instructions Dr Neubacher arrived by plane from Rome. The fate of the drachma was decided in Alexandria. This city, under British occupation, was the key centre of all black markets in the eastern Mediterranean. British currency experts had no influence on movements on these markets. Instead Dr Neubacher in Athens had such an influence, if he bought drachmas for gold. The British enemy

would have had to hoard forged Greek money, buy up drachmas in the years before. In their arrogance the British had not done so, because they believed they could control markets. Now they had to stand by and watch while the Greek currency recovered in only a few weeks. A late success for the Axis powers. Simply because Dr Neubacher, through his official arrival and the distribution of a few tons of 'Reich gold', gained through confiscations of Jewish property in Salonica, had for a short time succeeded in producing the appearance of wealth.

As if drawn by invisible threads, the exchange rate of the Greek currency rose point by point on the bourses of the neutral countries. Troops, decrees enacting compulsory measures, arsenals of weapons would have had no influence because they would not have been able to impress the capitalists of Alexandria who set the rates, men who drank coffee in scattered establishments.

10 December 1944: No one knows where, south of the Peloponnese, the ship of Otto Schilling, Reserve Major and banking official, sank in the Mediterranean storm. The experienced Wannsee Lake yachtsman had loaded 3.4 tons of gold from the Greek State Bank, a Reich loan, onto his vessel. It was presumably this treasure which pulled the wooden ship down into the depths. In December, the dominant bora, a treacherous north wind, makes navigation off the Greek coast almost impossible. The gold was to be brought to safety in Italy and then taken by train to Berlin.

10 December 2009: So-called December expenditures: the president of the Audit Office of the Hellenic Republic who is assisted by an advisor from the EU administration in Brussels has already been pursuing the usual 'December expenditures' for two days. It was impossible to do anything about them. In every state budget in the world the unspent sums identified are disbursed before the New Year no matter for what purpose. Because if they were saved the budgeted sums could not be reapplied for at the previous level in the following year. It would be better, said the president of the Audit Office, a legal expert who had studied at Tübingen University, if the funds could be transferred to the following year. Then at least they would be spent on something useful. There is no discipline of balance sheets which functions from top to bottom. In Athens, where the Orthodox rite is followed, Advent is less important than in northern Europe. Furthermore, here the twilight hours are absent which in trading cities accompany work on the annual closing balance sheet.

11 December 1944: WARSAW DURING ADVENT. An unusual mood prevailed among the 'last victors of the Third Reich' (as the commanders in Warsaw who had crushed the uprising of the Polish Home Army called themselves). There was not much they could do with the 'power' they had. Power without time. Later they knew that it was rule for another thirty days—how could one adapt to that?

Their power was all-embracing. In a sense it was free of inhibitions, because no time remained for any possible accountability. These were weeks of invention; experiences were collected. For when? Futility does not diminish the mistakes.

What might have been practical occurred to only a few. They could use these days to prepare themselves for the tribunals of the victors, the Poles who would soon be in power. They could get the files ready for that point in time; they could acquire friends if they were still able to find an enemy who could be won for them by favours or preferential treatment. They could deflect earlier guilt onto other departments, other jurisdictions. This obvious use of the days did not take place. It frequently happened that someone started a new life on the fat of the land.

The German quarters were intact. In Zolikow, additional villas were seized, more were taken over. Army Chief Administrative Officer Schmücker, a man of taste, carted seventeenth- and eighteenth-century furniture to the storeroom of a tobacco factory. There had never been such riches. He

managed to see off a train, loaded with exquisite items, in the direction of a mine shaft in the Harz Mountains. The man, who would never have been able to acquire such valuable objects himself, carried the shipment list, signed by the responsible rail official, in his breast pocket.

In the Bristol Hotel, which was integrated into the fortress structure of the German government district, Lieutenant-General Stahel wrote his famous report, based on his experiences, on 'Combating Insurgency in a City of Stone-Built Houses'. The headings were structured according to 'correct' and 'wrong'. An agent with a background in poetry, whom the Polish Home Army had infiltrated into Stahel's staff, later translated this record, put down in writing by the practised oppressor. Later still, this report was the basis of the stock of knowledge of the Polish secret services about the suppression of urban insurrections, a report which today in Iraq arouses the envy of the CIA.

12 December 2009: Twelve days before Christmas Eve, the waters of the heathen river Wangachu brought down the middle piers of the railway bridge which carries the Wellington–Auckland main line. Unusually heavy rainfalls are said to have been the cause.

The inertia of emotions dictates that, in New Zealand, even when the landscape displays all the attributes of summer, it is the wish of 'every one to go into his own city' as soon as Christmas Eve approaches. Consequently, the express train which plunged into the depths at the point where the bridge had given way was crowded.

The locomotive, five carriages. The electric lights worked to the last moment. I saw, reports a witness, the carriages disappear into the torrential river with the windows still lit up.

Of about a hundred and twenty passengers, forty-seven, rescued somehow, their injuries provisionally attended to, reached their destinations in Auckland. A relief train had been sent from the terminus to the scene of the accident.

—You exclude the possibility of sabotage?

—Who would have carried it out?

—You spoke earlier of the Wangachu River being 'animated'. The souls of Maori warriors whom the British colonial forces had killed diverted the masses of water towards the bridge piers.

—People say that. To me it sounds fantastic.

—But it's noticeable that the accident occurred right in the middle of Advent, in the run-up to the most important Christian festival. What made the heathen souls think of that?

—One can't construct a conspiracy theory around every odd event.

—But there's no need for a conspiracy theory.

—Why not?

—Because souls living in the water have no need of a conspiracy.

13 December 2009: AN EXAMPLE OF TRANSIENCE: the dental surgeon of the Milan hospital casualty department had to decide in a few seconds what to do about the prime minister's two knocked-out teeth. A metal model of Milan Cathedral had been thrown in the politician's face. Doctors were busy on the face wound, which was covered in green linen, setting the nose. The politician's bodyguards were behaving in an over-zealous manner because a short time before they had evidently failed in their duty. The surgeon responsible for lips and mouth was only able to cast a brief glance at the damage. It seemed to him to be no mere wound but a question of masculine signature.

The dental surgeon's turn came last. Thanks to American research it's no problem to produce replacement teeth of an appropriate whiteness. He could only estimate the shape of the prosthesis. What was to be done with the two broken-off pieces which only hours before had belonged to the living body? Should they be thrown away? Perhaps they were useful as evidence? So the surgeon handed these objects to the police in a bag.

The Emperor's Tooth

The mouth sore, the man declining. This human being who was held prisoner on St Helena was no Bonaparte any more, no Napoleon. At this time the left upper eye-tooth was still in his mouth. The tissue around the tooth bled.

He had had this tooth before Toulon, in Italy, in Egypt. He had hardly noticed the individual parts of his body. For years his senses had been directed outwards. His toenails, his neck muscles, yes, his heart and fingers (playing their part in a division of labour, hardly felt by him when they were healthy) had accompanied him on his campaigns. Sometimes one sensation or another in a hot bath or in other places of weariness after a hectic day. But he had never paid attention to the tooth. He was not susceptible to toothache.

Twelve weeks before Napoleon's death, a British doctor removed the piece of body calcium, this pitiful remnant, the image of its ancestors. He removed this tooth along with two others. The wound remained open for a long time. In that remote place, the will of the former Emperor, also the will of his body, was not interested in healing.

The tooth was kept in a case for several years and then, along with other items the Emperor had left, came into the possession of an aristocratic Italian family resident near Naples. A descendant of the family released the tooth, now wrapped in a little velvet bag, for auction at Sotheby's. It was knocked down at fifteen thousand pounds sterling. To an unknown bidder. So did this last trace of the great man, once so cosily stored away, disappear from public view. It is not known what interested the unknown bidder who acquired the relic.

14 December 2009: A MODERN BANK IS NO TREA-
SURE OF MONEY BUT A CHEST FULL OF PRECED-
ING ACTIONS AND COLLECTED ERRORS. The
delegations negotiated until dawn. There's flat water. The pret-
zels which were still being handed round in the early evening
have been eaten. Outside, meanwhile, a deep blanket of snow
which was not yet there when the negotiating parties arrived.
The highly indebted ALPE ADRIA bank is to be taken over
by the Austrian state and is thereby saved. A negative price
is agreed for the Bavarian Provincial Bank's shares.

The Consistency of the Moon

The satellite was a valuable piece of scrap metal. Transport
back to earth, however, would have been costlier than sacri-
ficing it. CLARITY had been established, thanks to a calcu-
lated impact close to one of the moon's poles. The metal core
of the moon constitutes at most three per cent of the lunar vol-
ume. I assume, said Sigurd Wolfsson, that a heavenly body
the size of Mars collided with our planet. As a result the moon
mass escaped. At first it orbited the earth at close range. The
moon must have filled a third of the sky when it shone.

—For our ancestors?

 —I don't think there were any ancestors yet.

 —Perhaps single-celled organisms, which didn't 'see' any-
thing? But felt it.

 —Every living thing feels something.

—And where did the Mars-sized planetary body escape to?

—We'll find it far out in space. A deformed piece of rubble. Still pretty large.

—Beyond Pluto?

—Beyond Transpluto. A dark lump of rubble, only visible against the sun. There the latter is thumbnail size. So I don't believe we'll ever be 'face to face' with the old companion of the earth, our collision partner. Measure yes, see no.

—So no one ever saw the 'stroke of fate' which perhaps helped life on earth to achieve a breakthrough?

—No one. But perhaps the WHOLE EARTH was animate at the time. The earth a huge living body, as it were. The giant Ymir, say the ancient texts, injured and struck down by a 'companion'.[6]

6 Russian scholar H. P. Blavatsky claims to have found texts in Tibetan monasteries which confirm these statements.

15 December 2009: It has snowed all night in the Engadine. With great fairness the snow lies equally on trees, lakes and plains. A light burden. In the early hours it is hardly possible to distinguish hoar frost and snow. Seen up-close, the heaped snow on the trees standing on the slopes appears as thick as the branches and twigs themselves. It speaks for the gentleness with which the snow settles that such an accumulation is possible.

High up the valley, on the other hand, close to the ridges and peaks, the clouds have dumped thousands of cubic feet of snow on a small area. A desert, or a swamp, to the extent that a walker sinks in up to his neck. Up here, conditions are like those in the icy terrain of the North or in the Hindu Kush in the East.

Tom Tykwer, who is still considering whether to turn down the commission for a documentary *Who was Jesus really?*, notes in his workbook that an angel of the Orient and the birthplace of the Saviour would be hard to imagine in a snowy setting. Easier to film the snow on the peaks of lofty volcanoes. At the snow line on Mount Etna, the white carpet of new snow borders directly on the black lava zone. That, says Tykwer, would be a motif for the beginning of a film. It would have to be called 'Nature's Paw', because it would be about the tremendous potential slumbering in the earth's crust.

16 December 2009

Veins of Light

There is a light within a man of light,
and it gives light to the whole world.

Gospel of Thomas 24

Sociologist Richard Sennett interprets the increase in revivalism in the Evangelical churches of the United States as 'compensation for lost status in the class structure'. An unbearable loss has to be made good. If, argues Sennett, the objective value of human beings, reflected in their labour power, is visibly denied by society, then the subjective value must approach the infinite.

This has led to a renaissance of interest in the apocryphal gospel of Thomas Didymos. In his LOGION, which competes with the Gospel According to John, it is confirmed, and by Jesus himself, that the light of which God, Son and Holy Ghost consist also shines in every believer. We bear this treasure within us.

In December 2009, this news gave unfortunate families on the western shore of Lake Erie so much strength that they joined together in eleven new sects, each of which, thanks to donations, meanwhile has radio stations, meeting places and news sheets of its own.

How shabbily does Bank Director McAllan stand before us, to whose bank our plot, all our property is mortgaged. Hardly payable in a hundred and twenty years (and now, after my dismissal from work, no longer redeemable). Yes, how pitifully does this administrator of our penury stand before us, when measured against the inner light which we, my family and I, held up before him. He did not dare eat any of the turkey we had put on his plate. He pleaded gastritis, promised to join our parish of the EVANGELICAL NEWBORN soon. No more demands for repayment of our debt. Perhaps we shall not even admit him.

17 December 2009: The ruse of the powerful was that they only intended to come forward just before the end of the consultations of the Copenhagen Climate Conference. Agreement on saving the world's climate was to be achieved by a packet of surprise promises. But then it turned out that the representatives of Brazil, India, China and the US (marginalizing the Europeans and Russia) talked for hour after hour without being able to agree.

The observers from OPEC appear satisfied. Meawhile, the representatives of the UN Climate Council shift their hopes. In their circles they say that the LITTLE ICE AGE which Planet Earth is still experiencing holds a quantity of cooling in reserve, so that the date of the consequences of the warming caused by carbon dioxide and methane has been further put back. Yesterday's assumptions have been revised. In fact, the thesis that all the glaciers of the Himalayas will have melted by 2050 has not been confirmed by computer calculations of the Climate Institute of Aarhus School of Business. Giovanni di Lorenzo, who wrote the leader for the weekly *DIE ZEIT*, was reminded by the Copenhagen fiasco of the failure of the Hague Peace Conference of 1907. Anyone who says that the twenty-first century cannot go off the rails, writes di Lorenzo, is mistaken; after all the twentieth century obviously did so. It's not about the Greenland glaciers, he continues, but the avalanche of disunity which became evident at this conference.

18 December 1941: A WRONG DECISION IN WARTIME. In the month of great uncertainties, in December 1941, Marita, the wife of the surgeon Dalquen, had come to Berlin from her provincial town, was staying at the Grand Hotel Fürstenberg on Potsdamer Platz and had refused the request of First Lieutenant Berlepsch to copulate with him. Only three weeks later she regretted her decision. The young officer fell in the fighting in northern Russia. She would have been a last comfort to him, and from that viewpoint would have judged the little card he had sent up to her room differently (they knew each other from a fancy-dress ball in the provincial town in peacetime). She would have stolen away to him. Now it was all too late. She had wanted to save up the promising relationship. Not squander it for the sake of a brief moment. She had liked the young officer.

Love 1944

The uncertainty, above all the lack of influence on whether and when someone will be struck down by the war, makes the soul bold. There is nothing to be lost any more.

So, after an air raid in 1944, which went on for hours, Gerda F. did not save herself up any longer. No thought of waiting for one of the returning warriors, whom she still knew and who would ask for her hand. She didn't want to get to know any better those left behind in the armament factories of the place. All were looking for closeness. She took a man who was passing through town up to her room. They never

saw each other again. There was nothing about it that she
regretted.

> 'For one night full of bliss
> I would give my all.'

19 December 2009: Twelve assistants to the US president, two budget chiefs and the White House national security advisor are preparing the largest budget in the history of the Pentagon, six hundred and thirty-six billion dollars. It must be ready for the following day. DURING THE NIGHT THE FIRST SNOW FALLS IN WASHINGTON. At 9 p.m. the president goes over to his family to eat supper. The security advisor leaves at midnight. The others work until five in the morning. When they come out of the White House by a side exit, the surroundings are snow-covered. It is a pleasure to step in the fresh snow.

ON THE ROOF OF THE WORLD. Far away to the east, nine time zones from Washington, the president's representative, Ambassador Richard Holbrooke, was driving along a mountain pass in a column of fast vehicles. He wanted that same night to reach a mountain settlement where a meeting had been arranged with tribal elders of the North-West Frontier.

The mountain region here is one of the highest in the world and, in December, one of the coldest. In this zone the singular surface at the boundary between earth mantle and earth crust is at a depth of forty-seven miles. The fault zone in the Indian Ocean presses powerfully against the Baluchistan Plate which, for aeons, has been driving the rock masses northwards where they come up against the westward trend of the Karakoram. Consequently, the mountain massifs of the Great Pamir, the Karakoram and the Afghan Hindu Kush have historically been

54

at loggerheads. The geologists call this part of the planet the THIRD POLE. According to geological researcher Abdel-Gawad, however, huge masses of snow, cold, fog and restlessness in the earth's interior are completely different from the static conditions in the Antarctic and the calm above the Arctic Ocean.[7]

Holbrooke's vehicle is not armoured. To distract assassins, a convoy accompanied by armoured vehicles is taking a different route. The Pakistani secret service has agreed to provide long-distance security for this column, which guarantees that the undertaking will be betrayed. It's not a good sign for the power of the US, that's Holbrooke's impression, that such a ruse is necessary. He hopes nothing happens to the passengers of the decoy convoy.

In the *political* geology of the region, made up of three conflict zones (Kashmir, Pakistan, Afghan Hindu Kush) 'frozen' and virulent crises clash within a radius of little more than three hundred miles. Negotiations and provisional arrangements don't count for much there, thinks Holbrooke, who brings all his skill into play, however, and can't wait to arrive at the agreed location.

7 M. Abdel-Gawad, 'Wrench Movements in the Balochistan Arc and their Relation to the Himalayan–Indian Ocean Tectonics', Bulletin of the Geological Society of America 82 (1971): 1235–50. One of Holbrooke's assistants has written a note on the tectonics of northern Afghanistan, so that the envoy is at any time able to make informed comments on occurrences below the surface of the country.

Freezing fog blinds the drivers. The vehicles' speed can't be turned to account on the gravel track which is called a road. The drivers have switched on their sidelights, so as to cause as little reflection as possible from the microscopic crystals in the fog.

'THREE WOLVES HAVE COME OUT CRAWLING / IN CHILDBED LIES THE GIANTESS / AMIDST ICE AND FOG AND SNOW.'

20 December 1832: UNEXPECTED CONVERSION OF A HEATHEN. After a difficult birth in the village, at which the 'Dingelstedt Witch' had assisted him, and after extended hospitality, Dr Wernecke set out through the snow back to Halberstadt. At first he took the path which the villagers, either out of habit or out of superstition, had created as a kind of VILLAGE EXIT INTO DEAD NATURE, because in this hard-frozen winter such a 'track' led into nothingness. Had Dr Wernecke not been so drunk he would not have risked heading for home. My first name's Klaus, I always get back to the house, he said to himself.

The snow crust was brittle. Wernecke broke through it at every fourth step. Then he had to draw his leg out of the hollow and at the same time keep his balance. This tired him greatly. The village disappeared from sight. It turned out, however, that the snow had formed hills. The roadside trees, which flanked the highway into the town, poplars planted by impatient French engineers, were covered up by the mass of snow. The doctor's gaze found nothing to hold on to. He thought it possible that he was going round in a circle. What use was his chronometer to him now?

As long as he kept moving he didn't freeze. No discernible horizon on the terrain which was as if covered by a shroud. A mist descended. If I sit down I'll fall asleep and be found as corpse after the thaw. Wernecke was essentially a cheerful soul, was not much given to reflection, was also considered a heathen: someone who tells jokes about God's word and in the

room of a dying patient asserted a doctor's expert knowledge against the babbling of the pastor. But now his heart sank.

If I start walking quickly and keep going straight ahead, orienting myself by the footprints I leave behind me, I shall, step by step, approach my town, my house where the servants have certainly already lit a fire. But the fall of darkness made it almost impossible for him to see his own trail. He did not want to walk back to check.

The endless expanse of snow produced a certain brightness in the night. Wernecke could neither say 'I don't see anything at all' nor 'I see something.' For that a clue would have been needed, a difference in the monotony of the snow-covered land. What good did it do him that he carried a knowledge of the map of Europe around in his head, which told him that this flat landscape (but now in reality forming a high hill) stretched in the east as far as the Urals and far to the west encountered great rivers which could not be entirely blotted out by the winter? He could only have succeeded in reaching this western country by crossing the Harz Mountains. No sign that he was walking towards the mountain range.

It was about ten minutes to midnight. His faithful chronometer accurately reported the time to him. At this point he gave himself another four to five hours to live. A pity if such a good doctor were to die, he said to himself.

For a moment, he was wiping his eyes with his cold hands, he thought he could make out a tiny flash in the distance. Now,

he thought, the delusions are beginning. He had read about them in the reports of the surgeon Baron Larrey: how in the desert heat of Egypt as in the icy wastes of Russia the Emperor's grenadiers had been afflicted by optical illusions and very similar false sensory impressions. So at first he didn't believe the SIGN that wanted to guide him. An iceberg of scepticism, which increases, rather, with tiredness, enclosed the exhausted man.

In short, the sign reluctantly and poorly apprehended, saved the doctor. It was in fact the lamp of the cathedral verger which the latter, climbing the tower stairs, at intervals carried past the windows. The verger was already late. He needed about ten minutes with two breaks for the ascent to the bells. The town would get to hear them ringing two or three minutes later than usual.

Dull-eyed, Dr Wernecke nevertheless resolved to trust the light that had soon disappeared. The light had guided his obstinate heart. So the doctor found his way to the first houses of the town. The church with its medieval nave, that lay there powerful and stranded in a largely unbelieving land, he, the heathen, endowed with an iron lamp which was affixed to the tower at the same height as the bells. Even if subsequently there were none who lost their way because the winters became milder and the physicians abstained from home visits, this lamp, at first fed with oil, later, at the instigation of the doctor's grandson, kept going by electricity, existed until the

air raid on Halberstadt on 8 April 1945. Since in spring (summer time was already in force) it was not switched on until 9 p.m. it was not shining when it was destroyed.

21 December 1945: The fifty-third birthday of my father Dr Ernst Kluge. His house at 42 Kaiserstrasse has been destroyed by bombs. The town has lost the rhythm of earlier years; its centre is in ruins.

My father's practice and apartment are rented. Sausages and hams hang in the pantry. It's locked. No birthday guest is allowed to help himself to this winter store. On the other hand, spirits of one kind or another are generously poured out.

At 5 p.m. eight musicians arrive from the Halberstadt Municipal Theatre which is provisionally accommodated in Heine's Sausage Factory. They play the habanera from *Carmen*, after that 'Ah, do not break yet, you exhausted heart' and 'Come, hope, let the last star . . .' from *Fidelio*. To close 'Traft Ihr das Schiff im Meere an' from the *Flying Dutchman*. Now the doctors from the District Hospital also arrive, Tacke, the corn merchant, Funger, Hohmeyer, Mayor Bordach, Gerlach, the two Schmidts (who are equally well liked), Fehling, Müller, Schliephake. The party goes on until five in the morning.

22 December 1943: A sledge stands in the living room. Test sitting on the present. Those sitting on the sledge are siblings. The twilight hour comes. Candles. We are all together. 'Yes, we are alive indeed / and even in the best of cheer / sitting out these times.' The father, a soldier, has come home on leave. The mother has been unfaithful. The children know that. They sing: 'Doch zwei, die sich lieben, / die bleiben sich treu!' — 'Yet two who love / Remain true to each other.' Their mother starts. Was it an allusion? The children, however, have betrayed nothing, only said the truth.

Now they all sing the song. It was the accompaniment to the last years of the war. It's about an armed soldier marching into foreign lands who is always yearning to go home. Such people are no good for winning victories. The women at home also sing the song: 'Es geht alles vorüber, es geht alles vorbei / Auf jeden Dezember folgt wieder ein Mai!' — 'Everything passes and nothing will stay / After every December there follows a May!' May had now been followed by December. It's dark outside. YET TWO WHO LOVE / REMAIN TRUE TO EACH OTHER.

23 December 1943: Time is Not Good-Natured

The author of a treatise with the title RIPPING TIME who was driving from Rome to the north of Schleswig-Holstein (the manuscript was by no means finished but he'd received a reminder about completion) was caught up in the BLACK ICE CRISIS which on 23 December 1999 turned Germany's roads into a trap. The haste with which he attempted to increase his STOCK OF HOURS AT HOME IMMEDI-ATELY BEFORE CHRISTMAS EVE for the purpose of acquiring ideas, stimulating his own feelings, was the cause of his vehicle plunging off the embankment and down a scree. With serious fractures his arrival at home was delayed by several weeks. His nearest and dearest brought him a little artificial Christmas tree assembled from three parts; it lit up the intensive care unit. Now he had time for the manuscript.

He called the publisher of the little volume immediately after New Year. The latter cast doubt on the soundness of the title. Treatise as genre description, said the publisher, was old-fashioned, and with *Ripping Time* the reader didn't know what to make of time ripping, and didn't it trivialize the book for the target readership because the antiquated schoolboy slang suggested something quite the opposite of what was intended? Then, replied the author, he would rather put up with lengthy explanations in the blurb and the foreword. The title was indispensable. There was a compromise, however, with respect to the description treatise. Publisher and author agreed not to define the genre at all.

What really was at issue for Fred Kelpe was this: time moves turbulently and urgently forward into the future, and it travels into what has been, where an immense substance of what has been torn away is waiting to return in a kind of lumber room or queue. In this stock of torn-away things lies humanity's reserve, its store of treasure. On the other hand, the life of what is carried away into the future depends on it soon being followed by the slower present times (otherwise what has been borne away perishes). But he can *hear* time ripping, writes the author. Not simply subsequently *see* it in the reactions of the victims (of violated cities or people), rather, it sounds 'like a screeching of the thing itself'. Ripping time, says Kelpe, is the only form fate takes which a person can feel before the blow falls. It can also, continues Kelp, be described, analogous to ocean movements, as *time delay*. The ship of life is held back in the current.

The process, however, is mightier than an ocean. Also more selective. A few villages to one side, a few seconds earlier or later and the torrent of time does *not carry off*. A human being five yards away from the tear-off in time is saved. From the tears and rips in time Kelpe concludes that there is a fundamental injustice in the universe. Is there a way through such rips into the abyss and from there to the underlying current from which everything new emerges? That is precisely what the treatise casts doubt on in numerous cases. Parts of living people (or of substance constructed by living people), also fatherlands and polities are separated from reality as if by a

lightning bolt of the gods and nevertheless do not arrive in the realm of possibility. That is the curse of Chronos, writes Kelpe, of an untamed monster which we take to be time.

23 December 1932: 'If a doe is dear to your heart / Don't let it graze alone / Huntsmen roam the forest and blow / Their horns, voices straying to and fro.'

On the last school day before the winter holidays, the teacher, Dr Otto Müller, chose these lines from the poem 'Twilight' by Eichendorff as the topic for the Lower Sixth.

24 December 1943: COMPLICATED SITUATION ON CHRISTMAS EVE. He had been called; because of the late hour on the holiday other doctors were not available. Skeleton staff at the district hospital, the case turned away. THE CHILD WAS LYING WITH HEAD AND FACE ABOVE THE PELVIC INLET. The contractions increased the pressure, nothing directed the living thing downwards, towards our reality. The child's head pressed against the mother's bone structure. In such a case only the OBSTETRIC FORCEPS are of use. This was (not today any more, as a Caesarean is usually carried out, but in the time of that obstetrician and doctor) an iron construction which clasps the sensitive head-end of the child on both sides, i.e. 'splints' it and, paying heed to the sensitivity of this little head, exercises a 'gentle, nevertheless iron, pressure' to transform the hopeless position into a promising one. 'Without force', i.e. the doctor has to find the pivot. The mite, who knows nothing about how he or she is supposed to be born, needs guidance. Meanwhile he must not suffocate. The 'self' of such a governing physician has seven thousand parts; he almost eavesdrops as he feels, and this with the help of the iron tool. In the hours leading up to Christmas Eve he had drunk four schnapps; that made some of his nerves sluggish. But then the emergency call had revived his powers.

The risk of the operation, of which he is well aware, is a drug. Something like a ship's master of Antiquity, but sensitive to every present, he manoeuvres the 'young thing', a mass of

protein with a structure billions of years old, into the birth canal. Beads of sweat drip from his forehead. He is agitated. He stops the agitation spreading to hand and elbow joint. Because the child, whom he is now guiding in the direction of the exit, is riding on his elbow joint; the little legs already out sideways. Two fingers of his hand hold the neck, one is in the mouth of the promising living thing. He brings this creature into the open.

The midwife who, like a shepherd in the field, has been waiting in the vicinity with towels and hot water, grasps the bundle, holds it vertically, forces out the cry. Meconium drips.

Now, after the successful birth, congratulations can be exchanged. A Christmas stollen is ready. The doctor takes the packed cake home. He has to bring something as consolation, he arrives at the party much too late. The child lies wrapped in a warm blanket. The mother exhausted. A grog will not do her any harm. When he drives home, he's already drunk. No obstacle, no oncoming vehicle. Happy Christmas!

25 December 2009: THE ASCENSION OF PILATE. In violation of the customs legislation of a number of countries an icon has found its way to Nördlingen. At the top left-hand side of the painting an angel carries the head of Pilate, which is surrounded by a halo, up to Heaven. In the lower part of the picture Pilate is beheaded. After 3 April, AD 33, Emperor Tiberius (top right on his throne) receives news of the execution of the Saviour as ordered by Pilate. The Emperor immediately summons the governor to Capri. He is beheaded on the night of his arrival. In the final hours before his death, however, Pilate professed his faith in Christ. Hence Pilate's head goes to Heaven. His profession of faith is also the reason for the halo distinguishing his head which has been detached from his body.

At bottom left of this depiction one sees the Pharisee who cast the decisive vote for the death of Jesus and who afterwards tried to bring charges against Mary and Joseph, the parents of the Anointed. He's in a sack, so representing the Roman punishment of that name. The leather sack soaked in water is placed in the desert sun and squeezes the delinquent's entrails out of his body. So shall each man learn what his deeds are worth.

The unique picture arrived in the German town just before Christmas and is to be presented to the mayor after the holidays.

26 December 2004: ST STEPHEN'S DAY. CHRISTMAS AS AVENGING POWER. The masses of water which drown a continent do not come as a tidal wave. They do not come from the seashore nor do they fall on us as downpours. They engulf us and our houses as waves of mud. We can't swim in it, can't dive. They roll towards us more quickly than we can run, because they come from all sides. See, how slowly, in comparison, this shifting hill, this mountain range moves. The streams on the surface and at the sides give watery advance notice, so to speak. How swiftly they merge, these monsters! Rushing down the mountain slopes their strength and power increases, because the fresh waters press more fiercely from behind. So the sludge and mud, against which dams and wooden walls are as little use as FLEEING or SWIMMING AWAY, flow over us, the Indios, Whites, heathen and Christian. There is nothing good hidden in this sludge-mass, which appears abandoned by God or all gods.

Some thousands have fled to the coast. Warships opened their sterns, took into their generous jaws those who, washed by the sea, were chasing towards them. The ocean effortlessly stops every mudslide.

Since the catastrophe had affected only part of one continent, but the planet has five of them, on the whole nothing moved. Houses, cars, people were carried away. A funeral service was not possible. The occurrence shook the Pacific Ocean more powerfully than it did the heart of mankind which beats as sluggishly as that muscle in a single human being, as long

as he is healthy. It twitches for a week, a series of emergency measures, announcements, a stream of donations.

Nor was there any search of the mud waste. Families were saved from roofs which protruded from the mud and flown away to be registered. Those who had been half-affected got by in cellars and roof terraces (in this country the winter days are warm) at the edges of the disaster. Police prefects visited the 'landscape'. Soon the emblems of the Son of God were seen again: fir trees, decorations, tinsel wound around fir twigs.

How does it happen? Latin America researcher Don Peterson asked himself. Where does this tenacity come from, that always moves the Christianized planet to celebrate once more? Invincible and not, as scholars thought for a while, a result of the Nordic winter night? Also certainly not explicable by a piece of news from Bethlehem two thousand years ago, a false lead from a research point of view. WHERE DO THE BEATEN PATHS OF SENTIMENT COME FROM AND WHERE DO THEY LEAD? Is it the price required by the gods? Does this power come from the Indios who say: Yes, you were able to massacre us, terrify us, but every catastrophe shows that while we have not survived, you will just as little survive. There is an EQUALS among the elements. There is a revolutionizer which outlasts your revolutionizers (the rapists, crucifiers, traders, murderous arsonists, bookkeepers). What can bookkeeping do against a mass of sludge, assuming that the latter is big enough and appears unexpectedly? What does

the sudden appearance of greenery, even before other elementary living conditions have been restored (water, electricity, food), do for human beings' sense of power? Do they feel a relationship with the destructive element, a mishmash which nothing can oppose, indeed, do they sense an AVENG ING POWER which, if it came out of themselves, would be frightening?

27 December 2003: She felt imprisoned. Before her, years of entry into an age-group which she had never acknowledged for herself. Raging around her and in her heart the competition between two loved men. In themselves they were foolish characters which, however, doesn't kill love.

She wanted to go back. Flee to a time in which nothing else was required except to follow her father into a life that was ruled by a loved authority.

The days of Christmas, i.e. the days after the excitement of the festival and before New Year's Eve, block any flight. They saturate with memory. Damp air from the west over the city.

She saw no alternative possibility except this one, since there is no REAL PATH BACK TO CHILDHOOD. She carefully prepared the process of destruction. The car, the hose pipe, the connecting piece to the exhaust. As place she chose a forest track which she had formerly regularly passed along with her father to access the footpaths. The track led to several possible routes. She drank, measured by her usual standards, MIGHTILY, finished a bottle of whisky, sat waiting, waited for the effect of her TOTAL INSTALLATION, coughed. At the thought that now she would disappear for all who knew her as an attractive, lively, still-young woman, tears came to her eyes. She couldn't see clearly any more, said one of her partners afterwards. Outside, rain instead of snow fell on the windscreen.

28 December 1989: The PALACE OF THE REPUBLIC is the pride of its engineers. All day and until long after midnight all the rooms are booked up. 'Every night is party night!' In the main auditorium the rows of seats, on which the deputies of the People's Chamber sat, can be tipped back as in a ship lift and the place turns into a ballroom. Here guests ate at a hundred and eighty-six tables and afterwards danced on six dance floors. No establishment of the republic's HO State Trading Organization can match the palace's entertainment. At four o'clock in the morning all the visitors have disappeared. The porters get ready for a drink. The cleaners move in, clear up. How happy employment makes one, how carelessly do the pleasures end. The kitchen staff sit together for a long time yet. Each one is the other's comfort.

Engineer's Pride

Formerly an engineer and high-ranking comrade in Magdeburg, I am now a private person, i.e. an amateur local historian in the town of Oschersleben. I am still in contact with the Municipal Museum in Magdeburg.

One of my research findings makes me feel proud. As is well known, the best Swedish steel that was ever used for building construction on the state territory of the GDR was incorporated in the Palace of the Republic. After demolition, fourteen freight-carloads of this scrap was sold to Dubai and there incorporated in the highest tower in the world, forty feet below the tip. So a part of our old world is preserved.

Extraterrestrials, visiting our planet in the year 6032, could identify (assuming the tower in Dubai remains intact despite indebtedness) the metal remains as property of the people, just as art treasures of Antiquity were found under the rubble of Pompeii and Herculaneum. I was able to publish a short note on this in the December issue of our local history periodical, *Friend of the Homeland*.

29 December 21,999 BC: Ice Age. In terms of climate one has to imagine this peak of cold (we are still living in the same ice age, though not in the Great Ice Age but the little one) as like a late afternoon in the Engadine in the Swiss Alps in December, said Alexei Tikhonov, scientific secretary of the Mammoth Committee of the Russian Academy of Sciences. No colder? asked Sylvie Charbit. Cold enough, if you can't find any fuel on the bare steppe and there's a lack of habitations.

In those days a weather forecast would have gone like this, continued the Russian: there has been a high-pressure area over Europe for two years. The incessant wind, blowing from the pack ice brings very cold, dry air into the region. An end to the extreme dryness, to the constant northeast wind, to the great quantities of dust it bears is not expected for the next four thousand years. From one in the afternoon the temperature falls below freezing.

And human beings flitted across the dry steppe which no longer exists today (with its grasses, nutritious herbs, but no trees)? Our ancestors, replied Tikhonov, did not 'flit' but searched, investigated and hunted in a race against death. If they did not find something quickly, they starved.

30 December 1940: SUMMER WILL, WINTER WILL. G, the grandson of the rabbi from Sboriw on the Strypa, landed on the shore of the Cavendish Laboratory of the University of Cambridge, remarked privately and in German, because it couldn't be expressed in English without some feeling of shame, that 'evil proves to be good displaced or straying in time'. In winter, however, the inner expression in human beings goes: 'RESISTANCE TO EVIL, DIGGING IN.' Summer will, on the other hand, can be expressed like this: 'GOOD AND EVIL TEST EACH OTHER.'

In summer both powers display a trial-and-error attitude, said G., as if a salvation came out of the clear or rainy summer sky as a gift. If such a summer will and winter will are combined as one, then confusion arises for the powers of the will. They are unable to occupy both attitudes to good and evil simultaneously because no one can manage two different attitudes to good and evil. In this fashion the one physicist went on talking to the other. Why, according to the teaching of the rabbi of Sboriw, asked his friend, can evil always only be good at the wrong time? If it is good in the wrong place, then is it evil at all? What is it then, if there are only two? Something like that cannot be a law.

No, but an experience.

Going by the intentions of their persecutors on the Continent the friends should have been dead. Instead, respected by the institute, they sat on the safe island. The conversation every night, the feeling of being together in safety,

could not last long enough for them. Abel would have had to be killed under any circumstances? That was a ticklish question which introduced time. What happens if Cain, who raises the stone, is checked by an accident or an angel, e.g. tumbles down a slope, loses the stone, dies, and Abel (we have to add in the influence of the women) becomes the exclusive ancestor of the species? Where has evil got to now?

One has to tell it in such a way, replied G., that the women talk to each other. So Abel learned from Cain's wife about the criminal attack, about his brother's deep envy, of which he himself had been unaware, and anticipated it. Then did Abel acting in pre-emptive self-defence kill his brother? Without the Angel of God pleading that this murderer in his turn should be spared? So that, responded the friend, the wife of the killed man or her children's children struck down this Abel, and so now both brothers die, which is not *good*. Something in Abel cannot have been good, if Cain turned evil because of it, the grandson of the rabbi continued his train of thought. The report points to something that was left out, added his friend: the cousins, the children, the women, the expert counsellors (priests) . . . so that Abel would in any event have had to die, but there would have been a solution, however, in which Cain would not have been author of the fratricide.

— A question of time.

— We won't get any further like this.

— Do we want to get any further?

No, they both wanted to stretch the time of this conversation, stay there together, look out into the night, where the English lawn was an invisible presence.

—We've got away from the point: Winter will. Did Cain carry out his murder in winter or summer?

—I don't know that.

—We couldn't undo it, but we could reduce the confusion in the reporting of it.

The grandson of the rabbi of Sboriw was lively now. How late is it? asked his friend. They had to be wide awake the next morning. Tiredness is not tolerated in the laboratories. Outside, British rain of the year 1940 beat against the windows. The point in time when a landing of German divisions on the island would have had a chance, had been missed. For the moment, depending on the season, 'the evil' contained in the intentions of the 'will' of the continent appeared to have no reality. One must not believe in evil, must counter it with disbelief. The physicists, relying on six thousand years of tradition, considered that a *hard* stance. They saw no point in imputing to the enemy, who was out to kill them, a unified will appropriate to a novel. Nor did feeling fear correspond to their wishes; rather, they wanted to sit together a little longer. Who knows what a bureaucratically muddled, unified will, encamped on the opposite coast of the Channel, would want next spring?

Perhaps we cannot calculate such a will, said G., but we can avoid consolidating it with our powers of imagination.

Under steady British rain, whose source was the wide Atlantic, prevailing Westerlies, the friends enjoyed, away from their work, their freedom from external, fatal willpower in the face of the inescapable changes in human willpower. For the moment they were very lacking in will, in a Western way.

31 December 2009: IMPRESSION OF IMPENETRABIL-ITY. In the collection of tales of the Brothers Grimm it is related that only twelve places were set for the 'wise women of the land'. The Thirteenth Fairy was not invited. Just as with the Chernobyl reactor disaster or the collapse of the Lehman Brothers Bank those facts are ignored which only a little later bring misfortune. The Thirteenth Fairy took her revenge by casting a spell which caused castle and kingdom to fall asleep for a thousand years.

She simultaneously surrounded the castle with a hedge of trees and thickets, the branches interlocking to form an 'abatis'. Snow lay on the boughs. An impression of impenetrability was given. In practice, in life, however, it proves that on the ground, with a light covering of snow, a way can be found through such a barrier. One only has to follow the picture down to the bottom where millions of mites colonize a single square yard.

The Power of 'Time'

What is it: 'Time'? I am a calendar researcher, not a physicist, replied the monk Andrej Bitov. It is the BUMPERS between the years that count, i.e. the turns of the year, the transition from day to night, changes (e.g. in the weather), the division into hours and minutes (also seconds, in which a person can die), into generations and individual biographies: time to be afraid, time to love.

So you mean, insisted the visitor, that time tolerates no interventions by the powers-that-be? That it is autonomous? Bitov replied: To whom does it belong? To that the biologist, Dr Fritsche, responded: It belongs to the cells, perhaps to Planet Earth itself, not at all to the individual. Here, he continued, guaranteed rights and liberties are at an end.

It's especially dangerous, said Bitov, to manipulate 31 December, the last day of the year. By nature no year ends. Six thousand years of prehistory are necessary in order to bring about the 'turn of the year', a cut in time. Without religion it's quite impossible.

CALENDARS ARE CONSERVATIVE

*Until 153 BC, December was the tenth month in the Roman lunar cal-
endar which had three hundred and four days. After that the beginning
of the year was put forward by two months but no one dared change the
name of the month that marked the end of the year.*

An Extreme Form of Inequality: A Rigid Timeframe

In the French revolutionary calendar the years are divided
into decades, units of ten days each, named after the natural
occurrences of the seasons. In this reckoning December has
disappeared. The period from 21 November to 20 December
contains the three decades of Frimaire (Month of Freezing
Fog). It is followed from 21 December to 19 January (the holy
days and a defined turn of the year are omitted) by the month
of Nivôse. The public holidays are corralled in September: 17
September (from 1800, 18 September) was the Day of Virtue
(Jour de la vertu), 18 September (from 1800, 19 September)
the Day of Genius (Jour du génie), 19 September (from 1800,
20 September) the Day of Labour (Jour du travail), 20
September (from 1800, 21 September) the Day of Convictions
(Jour de l'opinion), 21 September (from 1800, 22 September)
the Day of Awards (Jour des récompenses) and only in leap
years, on 22 September 1795 and 1799 and 23 September
1803 the Day of the Revolution (Jour de la révolution).

It was not hard for the autonomous elements in the feel-
ing for time of the inhabitants of France to overthrow these
calendar decrees. First they were 'counted double', after that
they were 'not acknowledged', and one of the first measures of
Napoleon as emperor was to abolish them.

97

A Mistake by Lenin which had a Belated Effect in December 2009 (and in January 2010)

On 14 February 1918, the Council of People's Commissars decreed the introduction of the Western calendar in Russia. How imperfect is the power of the state apparatus! The new counting of the days never completely replaced the old reckoning. The people of Russia have for a long time, without knowing it, counted according to both confessions, according to the Byzantine one and the Western one that was decreed.

At the turn of the year from 2009 to 2010 this led to the 'economic performance gap'. In vain did Prime Minister Putin attempt to deal with the irregularity. On the model of Western markets, the Christian holidays swept over Moscow and the territories beyond the Ural Mountains. They only ended, however, thirteen days later (both in terms of the way it felt and as far as work attendance was concerned), so that consumption of alcohol and reciprocal invitations to holiday dinners didn't stop. But now there was Epiphany, 6 January, on top of that, in fact the much more important holy day (with likewise thirteen days of felt latitude for play). Overlapped by the New Year: a considerable supply of festivities.

The replacement of reality (mediated by work and profession) by a seemingly endless succession of special days is, according to the monk Bitov, equally disastrous for body, soul and economy. And all that because a provisional revolutionary government tried to rule time, something which only God and the people have the authority to do.

On Calendar Reform

Between the present-day republics of Kyrgyzstan and Tajikistan there is a narrow strip of land, framed by high mountains, which was not marked on the maps of 1917 nor was it recorded by any of the later administrations. When the Soviet Union broke up this area was left over. There was an Orthodox monastery which was hurriedly evacuated at that time. A single monk remained behind, in order to guard the building and to continue the monastery's work.

The monastery had for centuries been concerned with the official determination of calendar dates for the church, i.e. with chronicles. The isolated monk, instructed, forgotten, did not remain alone for long. Through the Internet he is linked to fraternal organizations worldwide, whether Orthodox or scholarly. His Muslim surroundings, no longer aware of this alien, do not bother him.

Brother Andrei Bitov divides up the most recent centuries as follows:

From the Peace of Westphalia

1648 to 1789	1 century
From 1789 to 1792	1 century
From 1793 to 1815	1 century
From 1815 to 1870/71	1 century
From 1871 to 1918	1 century
From 1918 to 1989	1 century

so that three hundred and forty-one years have the substance of five hundred.

After that: the present day.

The years which Bitov is short of in this computation of modern times he recovers—in agreement with Dr Herbert Illig on this—through a critical revision of the dating of the Middle Ages. There are invented periods here, e.g. there is no proof of the existence of Charlemagne. About three hundred years don't exist at all. So Bitov has no difficulty with a turn of eras at the birth of Christ which he needs in order to synchronize the monastery chronicles.

In academic circles in the US Bitov is now seen as the inventor of TIME COMPRESSION. The quality description 'century' has a morphic structure, i.e. it forces the years into circular or elliptical orbits around a centre. It is arbitrary to count them off chronometrically according to days, years. Hence the three years of the Great French Revolution have a 'distinct structure', says Bitov. That makes them a 'century in itself'. The RIGHT TO SELF-DETERMINATION OF TIME MUST BE ACKNOWLEDGED LIKE THAT OF PEOPLES.

Why should the same be valid for Russia as for Britain and France? Here Brother Bitov becomes agitated. All times are different, a British and a Russian century can certainly not be compared. However, says Bitov, the times of the continents and their inhabitants are linked to each other by way of morphic fields. To that extent the CURRENT OF TIME is once again

synchronous. And it is not even certain that the Great French Revolution is really of French origin. A new age or time can have its origin in quite other places from where the phenomenon breaks out (surface). We have discovered souls in Russia, in Central Germany, in Tashkent, likewise in Portugal and its East Asian colonies which set themselves in motion together.

Fuel is rare in Bitov's mountain monastery. In winter he can best warm his hands when he places them firmly on the casing of his computer.

Future Perfect

What manifests itself in my story, the story of a living person, is not COMPLETED PAST (what was, because it no longer is), also not the perfect tense of what has been in what I am but instead the OTHER of what I shall have been for what I am in the process of becoming.

—If I understand you correctly, it's about the mourning for 'what I am in the process of becoming'. I can already see: I shall have been a criminal, which I didn't want to be at all. I travel to occupied Paris on one of the first trains after the armistice, in civilian clothes, my ID states that I belong to the innermost circle of Reich Central Security Office, delegated and sent out to organize the understanding with France which Freiherr vom Stein failed to achieve in his day. I do not know yet that a year later I will have to take charge of mass shootings in southern Russia for which I shall be badly rewarded five years after that.

—And you could not express that in the future perfect at all, because you have already been executed in Krakow. Your future has been cut off like a head by the guillotine.

—But after all I am merely putting myself in the position of an imagined person who became a criminal. I'm sitting here in front of you, with a drink.

—But there's also the I SHALL HAVE BEEN, one of the most powerful projections of will power. Not to be confused with what I really do or shall do.

—And what is the use of this grammatical mood? It gives us problems in German. It sounds complicated although it's so simple in life?

—It's the point at which I decide.

—To the extent that human beings have this point at their disposal. As the song says: It's something you can't guess, cheerful little doe.

—It's the capacity to guess at all and the decision which I, looking forward at myself, take. 'Choose only a future you can bear!'

—Grammar is a dangerous weapon, an instrument of murder.

—The only weapon consciousness has available to it.

Siberian Time Reserve

Comrade Andropov, his health always fragile, hence loath to move and not keen on travel, was still in charge of the KGB but preparing himself for the position as General Secretary of the Party. At the time, there was in one of the main sections of the Soviet Secret Police a Kyrgyz, Colonel Lermontov, whose ancestors included pagan priests (Siberian animists). In his office hours (in such a vast organization with a planetary presence immense quantities of time slip by, they flow more slowly than anywhere else in the world outside the windows of the tall concrete building) he put together a collection of historical sketches. A number of these sketches were concerned with 'paralysis at the decisive moment'.

It is a curious fact that the great villains of world history are often seized by a paralysis and that at decisive moments. It would be doctrinaire to maintain, says Lermontov, that there are no gods. Evidently they make themselves felt as encouragement or paralysis. Do you, Lermontov asked listening comrades, seriously want to hold a cold responsible for Napoleon at Waterloo not fighting the battle of encirclement which his generals advise and which guarantees certain victory? Do you want to explain the failure by a cold?

No, by the Emperor's lack of belief in his own mission, replied one of the learned secret service assistants, who was educating himself every day (in those years they were all educating themselves for Perestroika, of whose coming they had a premonition, without anyone knowing what name the new freedom would have).

I dispute that, retorted Lermontov. The god who paralyses him is the same as the one who struck as a bolt of lightning between Trojans and Greeks.

You say that as a materialist?

That's exactly what I say, replied Lermontov. A materialist is never doctrinaire. He does not without reason exclude the influence of *any* power in the world as impossible. Above all, not when it opens itself up to our observation. Take Hitler's strange paralysis, his blinding (at the very moment of the fiasco at the front outside Moscow). In December 1941: 'as if snow-blind'. He declares war on the US. He was not bound by treaty to do so. He seals the end of the Third Reich.

I'm very surprised, interjected Lermontov's superior, who had joined the group. *What* exactly are you working on, comrade?

The then-still-intact imperium disposed of all the time reserves of Siberia. And so over reserves of ideas: a strong-room of the life of the soul. Academic elites of the land gathered in the bunkers of the KGB.

I (Gorbachev's last assistant) was reminded of Lermontov's reflections as I observed the president's paralysis. It struck him after we returned from the conference in Madrid. We went begging there. He was never again the man he had been. A capricious Mediterranean god of ancient times, who at the side of Athene helped destroy Troy, had got into him (as viruses, insect bites, poisons, great disappointments are able to do). So he sat in his room, idle. While the 'Gang of Eight' hatched their plot, dispossessed the state. Should he have had them arrested for high treason? He had the authority to do so.

We buried Colonel Lermontov shortly after the disaster at Chernobyl. 'Abandoned by all gods', he had shot himself.

Tempus, Aevum, Aeternitas

We Islamists, said Jamal Islam, astrophysicist from Bangladesh, familiar with Sufi texts which since 1150 have only been passed on orally, as God wills, deal with three sorts of time. I look at my watch, I read TEMPUS, this is operating time, it links me to the atomic clocks of the scientific world. In this time measurement earth and sun move in the context of the Milky Way, so in only two hundred and fifty million years they circle the core of the galaxy in sweet harmony.

AEVUM is to be distinguished from TEMPUS. It is the disembodied time of angels. I turn my inner gaze to the centre. There Allah's black sun shines from the inside out. The origin of the BLACK LIGHT lies to the west of the solar plexus. Heretical, to confuse the sensation between diaphragm and solar plexus, which is felt in states of fear or happy agitation, with the radiation of angels. Only the centrality of millions of believers allows the radiation of the AEVUM to emerge, on which the souls travel up.[8]

8 As a physicist I would like to illustrate the theologically comprehensible facts by way of a parable. We astrophysicists are looking for gravitons. I myself am involved in the development of a gravitational wave detector. The interaction between a particle of our earth and a point on our body can no more be measured than that between a point of our divine body and a point of our earthly body and is no more practically relevant. But if we say to a physically strong person: here is your place, here you must leap, then the bundle of human body and takeoff power is that combination which on the one hand demonstrates marvellous leaps towards heaven (also in the case of gazelles, jerboas, fish in mountain streams) and simultaneously the enormous braking force of the planet.

The third kind of time, AETERNITAS, is the duration which only God experiences. It is once again heretical to confuse this universe of time with TEMPUS or AEVUM or even to link it to them.

A European ambassador, collecting information, was consulting the scholar. The ambassador was a medievalist.

—You use the Latin terms of Origen. Why?

—We are engaged in a debate which has been going on since the year 1080. It involves Spanish-Islamic texts. We read them in the Latin translation. The Arabic version may only be transmitted orally.

—And changes over time?

—It cannot be avoided.

—From the Latin translations of the early Middle Ages you measure the distance to the wandering stories which Islamic scholars relate today?

—Don't speak disrespectfully of something that is sacred.

—The slips of the pen, errors and often senseless additions of the monks who altered our Western texts, they're surely not sacred?

—Hence our oral transmission.

—Which admits even more mistakes?

—Changes. Allah prevents mistakes.

One cannot, explained the Islamic scholar, travel from one of the three universes, which are here described as time, but also comprehend yet other substances (e.g. aromas, necessities), into another. They are cut off from each other. A believer loses himself as soon as he changes from one time to another without ritual observance. Out of the black radiation he looks at his watch? Yes, that bewilders him. And coming from AETERNITAS? He doesn't belong there.

—Are you talking about a theology which incorporates physics?

—What else?

The conversation was conducted in French. The researcher of medieval history, who served his country as a diplomat, could to some extent talk openly to the scholar from Bangladesh, because they had already been doing so for forty years. Islamic imperialism, said the diplomat, reminds me of the old Soviet Union. It had invented aviation before the first aeroplane existed. In southern Russia it looked for the first men, looking to the stars it overtook all other industrial countries. The comrades annexed the world, as materialists, without troubling about religion. But you, my friend, (and I do not wish to detach you from your phalanx of all believers, we are friends, we can be that, even if each considers the other a heretic) explain the

115

movement of Islam to me in such a way, that it holds everything valuable in the world and we should prepare ourselves for Siberia and the Midwest soon becoming Islamic. You say that without any regard for material conditions.

Curious, replied the Islamic scholar. At the moment I'm working on a translation of Friedrich Engels' *Dialectic of Nature* from the Russian (unfortunately I don't read German). It addresses THE VITALIZATION OF THE TOTALITY OF INTERSTELLAR SPACE. All forms of matter possess a kind of low-level life. Non-conscious life creates the biosphere. And from this through lightning the noosphere emerges. You mean in the year 1080, put in the diplomat? That's what I assume, replied the Islamist.

The acquaintances of so many years sat in wicker chairs, to some extent timelessly or in a neutral zone between the times of TEMPUS, in the lobby of one of the grand hotels which indicated that this meanwhile threatened world terrain was once subject to British rule. These hotel liners are stranded like embassies of a sunken world, but inside reflect a mental comfort which suggest a state of affairs in which one could make oneself understood among people everywhere in the world. Over cold drinks and with a cool head place all the questions of philosophical and lived practice side by side and, as on a medieval pool, e.g. in the great city of Damascus or in Cordoba, choose the best. So does a merchant bring his beloved daughter gifts from afar, so do storytellers travel and

bear the latest and most interesting news to remote parts of the world. The walls which sheltered these two so very different scholars were, it is true, of imperial origin but for the moment it was a place in which no empires were being founded or were expanding. The new imperial arm, this was the diplomat's fear, was more likely emerging in the slums five miles from where they were sitting. And the no-longer-young astrophysicist sitting opposite him would be one of the first to be consumed by these greedy jaws of the AEVUM, once such a POPULAR WILL pushed its way out of the AEVUM into the TEMPUS.

The Demarcation of Old Year and New Year According to German Industrial Standards (DIN)

On 6 December 2009, negotiations in Geneva between the Federal Republic of Germany and the People's Republic of China to establish mutual acknowledgement of industrial standards broke down. Among other things, this was because China does not have general rules corresponding to the DIN norms. Consequently for trade with the People's Republic of China (also for possible diplomatic notes and declarations of war) the relationship of the Federal Republic to this great country remains indeterminate.

According to German law the following applies: December begins with the same day of the week as September; so if 1 September is a Monday, then so is 1 December. If 29,

30 or 31 December is a Monday, the days from Monday of the first calendar week are included with the following year. In accordance with the DIN norm in this case the last calendar week of the year ends with the last Sunday of December. If people wish to experience one to two more weekdays then they do so outside of time. Organizations on the other hand always move forward in fifty-two intact weeks.